"SEE ME! - TOUCH ME!"

The eroticism of touch

For Nadja Flügel

Hans-Jürgen Döpp

Publishing Director : Jean-Paul Manzo

Text :Hans-Jürgen Döpp

Translation : Jane Rogoyska

Design and layout : Cédric Pontes

© Parkstone Press Ltd, New-York, USA, 2001
ISBN 1 85995 815 X
Printed in Hong Kong, 2001

"SEE ME! – TOUCH ME!"

The Eroticism of Touch

"Don't touch!" There is nothing more unnatural than this eternal prohibition which occurs in art exhibitions and forbids all contact with the objects on display. They occupy space, they are three-dimensional, and we experience them with our sense of sight, but we also feel the desire to touch them. Nevertheless, this ban on touching seems to have an unexpected effect on people: under the humorous title "An evaluation of the consequences of contact with art: the marble of love", the Frankfurter Allgemeine Zeitung of 23rd June 2001 published the results of an extraordinary poll carried out by the Institute of Psychiatric Psychoanalysis in Rome. They questioned nearly 2,000 museum visitors, and discovered that the fact of being exposed to art directly stimulated people's erotic senses. One fifth of visitors admitted to having felt, after their virtual encounter with statues and other sculpted figures, an impressive series of very concrete sensations. Some mentioned "vague but intense experiences", others "a keen feeling of love" or "unexpected feelings." Even the relationship between long-standing couples seems to experience something of a filipp as a result. Thus the sculptures of Canova, Berni and Michelangelo seem to have a kind of aphrodisiacal effect which is difficult to reconcile with those ideals which state that art only stimulates the most disinterested form of pleasure.

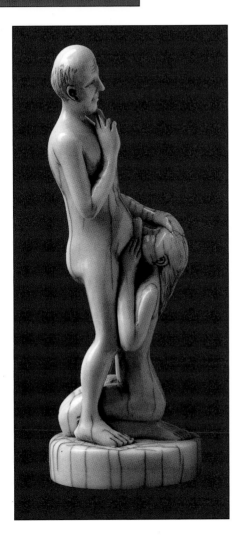

Chessmen
Ivory, King and Bishop.

And yet surely the interiors of Catholic churches, with all those languishing virgins and galleries of naked, martyred bodies, are a school of sensuality in themselves? Do we have to conclude that museums and churches are dangerous places because they awaken a desire to touch?

Chessmen
Ivory, King and Bishop.

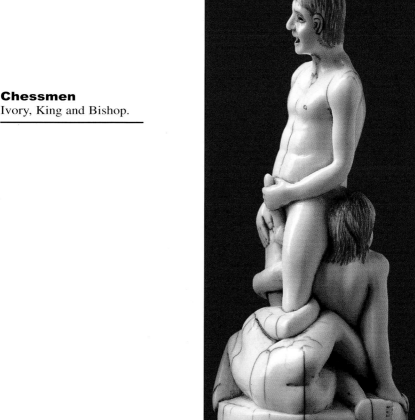

5

Krafft-Ebing, in his Psychopathologia sexualis, gives us examples of acts of aggression commited against statues. He mentions, for example, the story of a young man who used a Praxiteles' Venus to satisfy his desires; or the ancient story of Clisyphus, who abused a marble goddess in a temple of Samos after having placed a piece of meat on a certain part of her anatomy.

Cigarette Box
which belonged to the
Maharadjah of Cooch
Bihar in Bengale, or rather,
Bihar. Ivory. The box was
made in Italy at the end of
the 19th century.

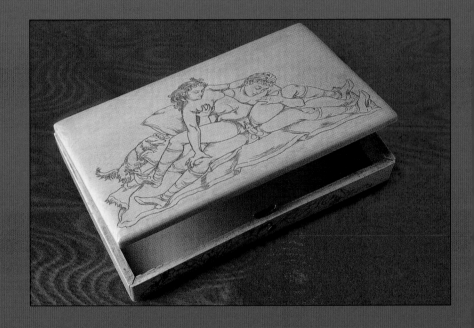

He also tells of a gardener who, in 1877, fell madly in love with the Venus de Milo and was caught rubbing himself fruitlessly against his beloved. However, Krafft-Ebing does not question the pathological or abnormal nature of these cases.

(At this point the author can freely recall his own personal experiences during youthful nocturnal escapades in a park where there was a group of sculptures by Georg Kolbe which initiated him into the pleasures of touch. It was here that he understood for the first time how art can be erotic.)

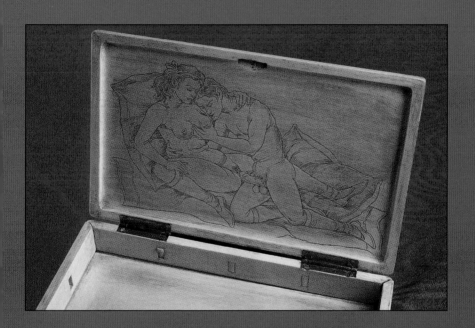

Our sense of touch is a sexual sense in the most profound sense of the word. That is why Mantegazza describes physical love as the most developed form of the sense of touch. Ivan Bloch, following a similar argument, even speaks of the skin as 'one single sensual organ.'

In order to achieve the natural conclusion of desire, one cannot do without touch: looking and touching are generally the two acts which precede the sexual act itself.

It is not by chance that Freud mentions that "the sensations of touching the skin of a sexual object first of all create a new source of pleasure and a swelling of excitement." Even if looking remains the normal route to sexual excitement, excitement also comes from touching. "Seeing the sexual organs naked gives us the desire to touch them. And as is often the case, looking replaces touching."

The Curious Mother in Law,
Polychrome porcelain, Vienna, second half of 19th century.

Tender Lovers
Polychrome Bisque Porcelain, Vienna, Biedermeier.

8

Kissing forms part of these exciting sensations. Freud writes rather seriously on this subject: "One specific form of contact, that of the mucous membranes of the mouth, has gained amongst many peoples (including the most civilized) its own significance as a kiss, even if the body part involved is not a sexual organ but the entry to the digestive canal."

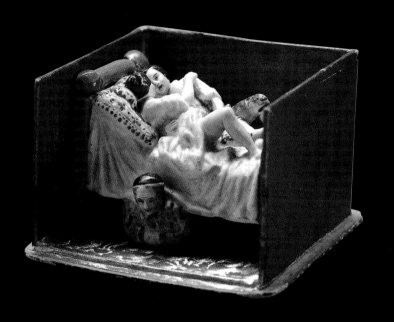

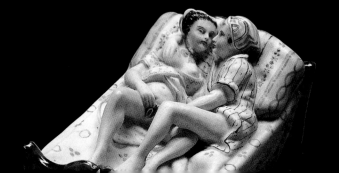

Cigarette Holder
Made from meerschaum
and amber, historism,
second half of the 19th
century, probably from
Vienna.

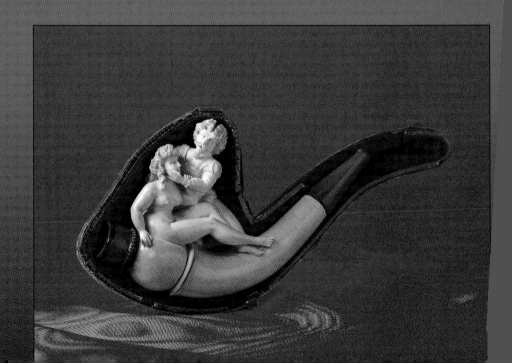

Cigarette Holder
Meerschaum, Vienna, the
middle of the 19th
century.

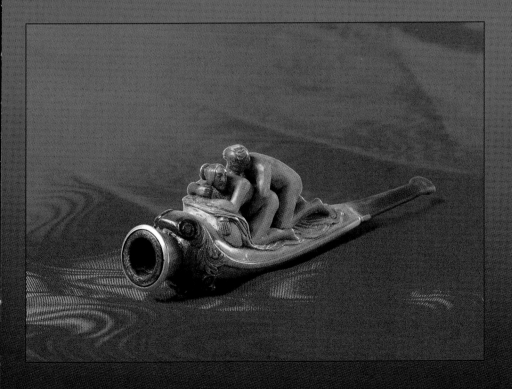

Ithyphallic Minotaur
Bronze of the Munich
gynecologist,. Rudolf
Rehbach (b. 1951), 1976.

Lady with little dog
ca. 1920. Terracota.

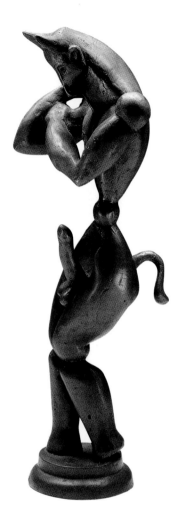

12

Indeed, after birth, isn't the mouth the first erogenous zone? Touching and looking are temporary but very exciting sexual pleasures. A useful technical comparison in a book about 20th-century customs can help us to understand better the difference between these two modes of sexual appropriation: "If the eye is in some sort the telegraphic station of love, then touch is nothing less than the electric contact that makes the morse hammer move."

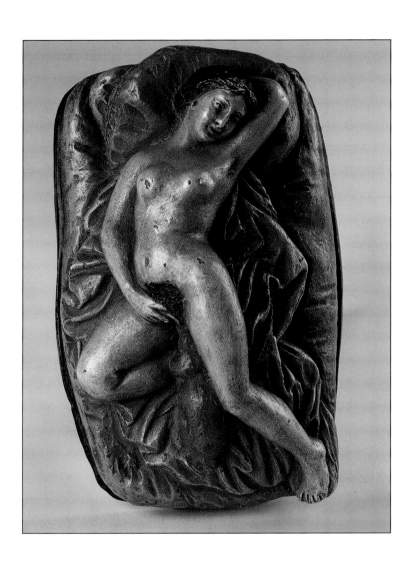

Literature is full of examples of caresses between lovers which are far removed from the sexual act itself, but which can provoke states of violent excitation.

"Ah, how the blood rushes through my veins, " exclaims Goethe's young Werther, "when my finger accidentally touches hers, or when our feet meet under the table! I draw back as if from fire, and a secret force pushes me on

Solitary Pleasures
Painting on ivory,
Biedermeier.

**Happiness from
Behind**
Ivory medallion,
Biedermeier, adapted from
a painting by François
Boucher (1703-1770), a
favorite painter of
Ludwig XV.

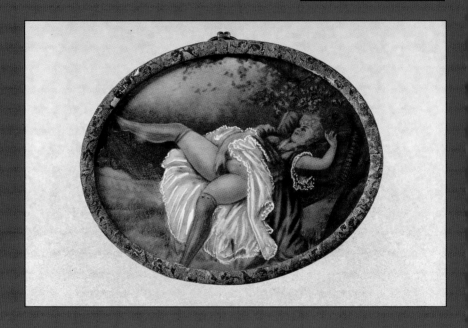

again – and I feel something like vertigo all through my body. – Oh! Only her innocence and her unprejudiced soul prevent her from realizing how these little familiarities drive me to distraction. And if during a conversation she puts her hand on mind and comes closer to me in order to speak more clearly with me, and thus I feel the divine breath from her mouth on my lips, I dream of falling, as if I had been struck down!"

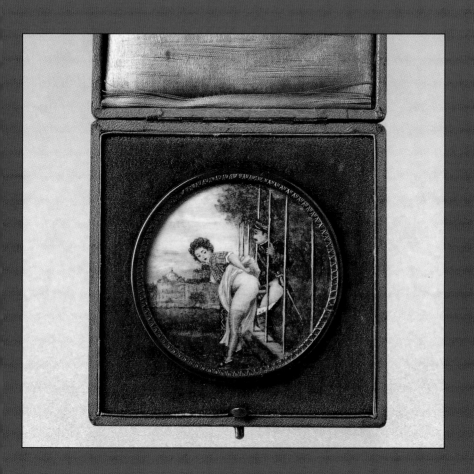

Like Goethe, Rousseau describes in his Nouvelle Héloïse the exciting sensations that a simple light touch can provoke: "As soon as her hand rests on mine, I am overcome with shivering; this game plunges me into a fever, or rather into a kind of madness; I can no longer see or feel anything…!"

The feelings which Voltaire describes in his Pucelle are, by contrast, more overtly sexual:

Satyr and Nymph on Arabian Rug Performing Cunnilingus
Viennese bronze by Bergman.

Lovers
Bronze by Casarotti.

"And gradually, her hand
began to lose control
and to open, trembling with pleasure,
her corset, lace after lace;
Ah, he touched her, looked at her,
Took her in his arms, explored her,
Embraced her and gave her pleasure.
Everything was beautifully round and full,
And pleasant to the touch
And her mouth was quite red
Ready to gather his kisses!
Everything moved in every sense
And both hand and eyes looked
Towards the lovely gardens of pleasure."

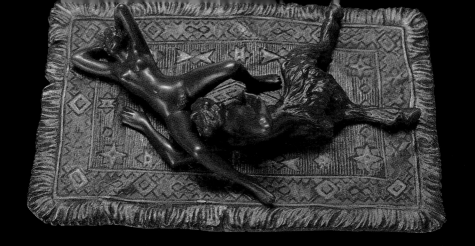

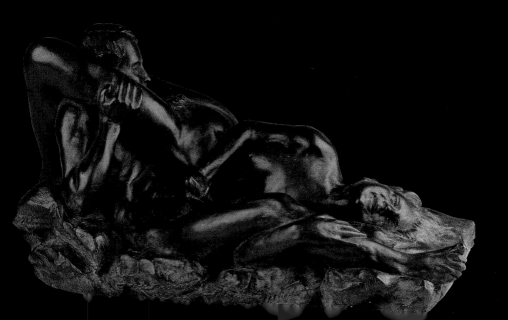

Ball Clocks

The Company Doxa from Le
Locle (Switzerland),
established by Georges
Ducommun (1868-1936).
Casing made of argentite (new
silver or china silver). Painting
and reconstruction of erotic
clocks started in the 1880's in
Budapest. Penis is the second
hand on the clock face.

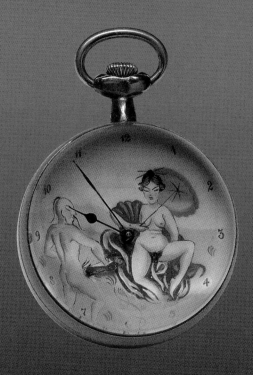

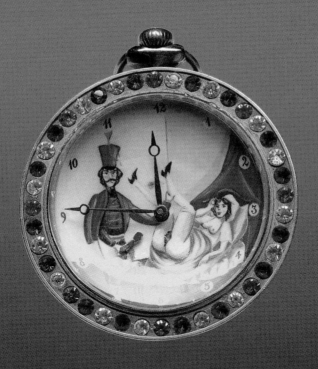

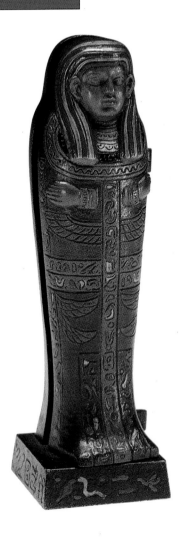

Egyptian Sarcophagus with Girl
Franz Bergman, Vienna, Jugendstil. Bronze, ca. 1905.

20

The hand follows the eye – as with an infant who wants to grab an apple he has glimpsed. However, touch is not secondary to sight. It is only genetically preceded by it. Kissing and hugging, touching and feeling are the primary experiences of sensuality.

However, tactile stimulations are not limited to the hand, they can also be provoked by the foot and can lead, in some cases, to orgasm. In his books on Psycho-sexual Infantilism, Stekel mentions such a case: a 34-year-old traveller, who was particularly excited by

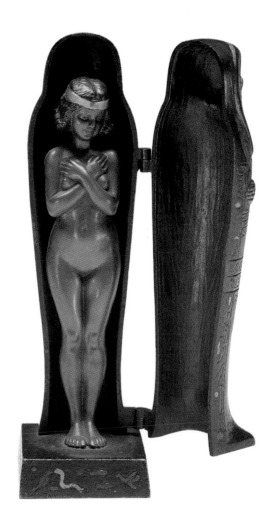

stimulation of his skin, used to like to go to a brothel and have his body tickled slowly from top to bottom. When the girls who were tickling him reached the soles of his feet, he would have an orgasm.

In the light of this story, is it suprising if, as Havelock Ellis wrote, the Patagonians have only one word to describe both sex and tickling?

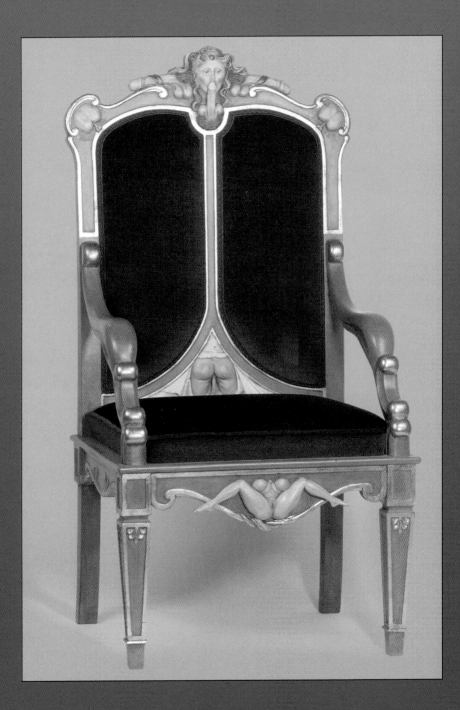

Chair Carved and adapted
after photos of furniture from the estate of Katharine the Great.

A Brothel Is Opened
by the French artist Dominique Larrivez who thus protested against the closing of bawdy houses. They were closed on April 13, 1946—the Maisons Closes in France.

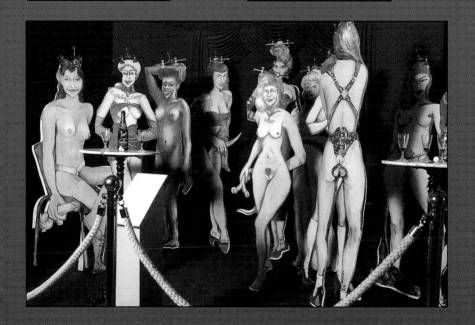

23

It even appears that in the 18th century, at the court of the Russian Tsar, there was an official post of 'foot-tickler,' whose sole duty was to tickle her master's feet. Anna Ivanova created this post, as B. Stern reports in his History of Russian Customs, and it was a prestigious position at court. The princess regent Anna Leopoldovna, having after the death of Anna Ivanova obtained the guardianship of the infant

Walrus Tooth
With erotic engraving, 19th century.

Ivan VI, used to keep up to six official foot-ticklers in her private salons, and their delicate art was organized in the form of a competition. During the tickling sessions, the women told each other bawdy stories and sang obscene songs. Whilst the erotic value of reading has been rediscovered with the release of the film La Lectrice, tickling as an erotic activity has yet to enjoy a renaissance.

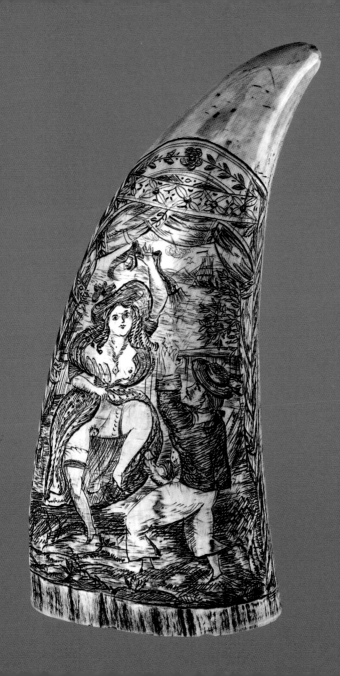

**Man Walking
a Giant**

Bronze, ca

Tribute to
Group made of
painted with oil. Sc
Germany, 18th c

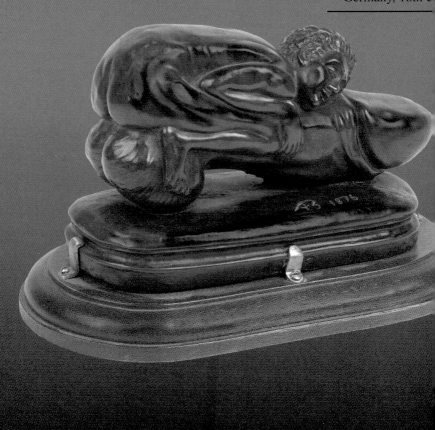

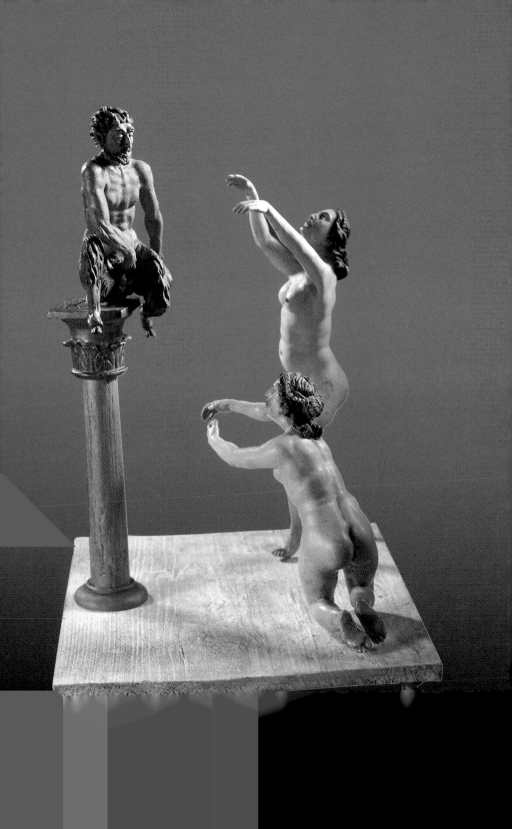

Lovers
Original is a bronze
casting by Casarotti,
1910.

28

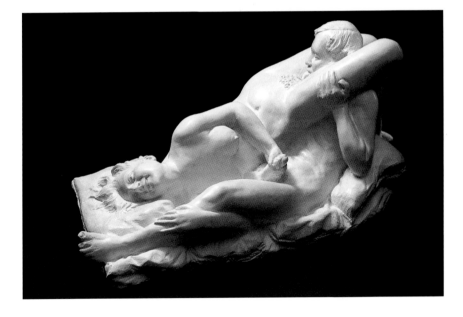

The skin is doubtless the most sensual organ of the body, but it is also something on which all sorts of punishments can be inflicted: flagellation, stigmatisation in various forms, and sometimes even torture to the death, as the Greek god Apollo inflicted on the satyr Marsyas. The skin is thus the organ both of pleasure and of pain.

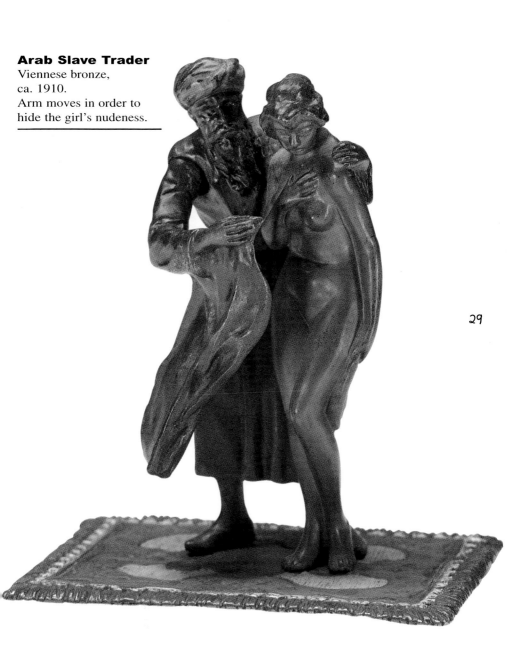

Arab Slave Trader
Viennese bronze,
ca. 1910.
Arm moves in order to
hide the girl's nudeness.

29

Erotic jewel box
It contains three ivory dildos and a small ivory cream bowl. This object, of fine workmanship, which might go unnoticed when closed and sit on the sideboard of any decent bourgeois household, comes from England and dates from the second half of the 19th century.

In his seminal study Bodily Contact, Ashley Montagu examines the significance of the skin in terms of human development. Contrary to established opinion, which holds that the process of learning is carried out by the eyes and ears, he demonstrates that knowledge is also passed on via the skin. The embryo develops a sense of touch long before it can see or hear. In the mother's body, the principal organ of perception is the skin. For the infant it remains the

basis of all contact and of all communication with the world. Thus he can tell the difference between being picked up by someone who loves him or someone who is indifferent to him. Even as adults we still have this power of discernment. Through the different experiences of touch, the infant slowly learns the importance of each instance of contact: tenderness and warmth, consolation and caresses.

Even linguistically, 'tender' and 'consoling' have their origins in tactile sensations without which they would have no meaning. Thus the language of touch is the first language. There are so many words and expressions that express our most important feelings, and if one considers the varied uses of the word 'touch' in every language, it is clear that

The Sheik's Cat
From the Arabian series of Bergman, Vienna. Designed by Tiffany, New York.

32

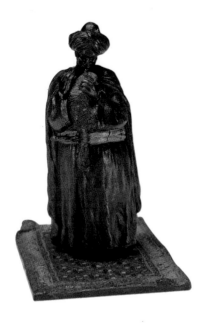

they are all variations on the same theme: touching with a hand, a finger, or all one's fingers. It is hardly surprising that there are a huge number of entries under the heading 'touch' in an English dictionary.

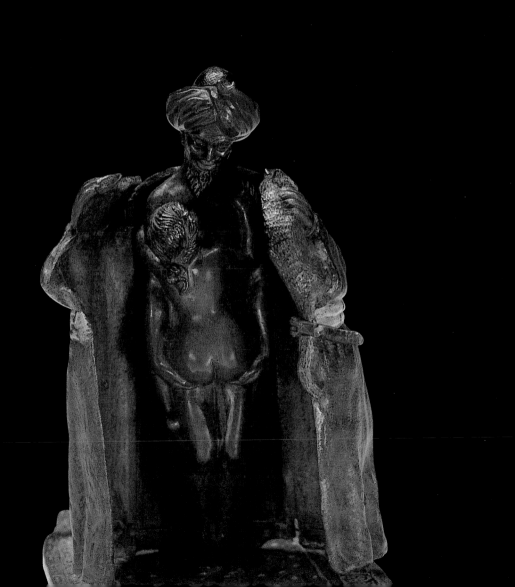

Replica of Chastity Belt, Middle Ages

Worn by a Lady in the absence of her knight to prevent unfaithfulness. These curious objects, however, belong mainly in the area of myth making.

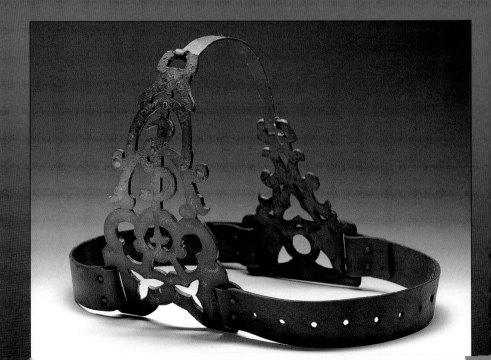

Chastity Belts

Early 17th century. (Venus Bands, Virgin's Belts, Modesty Belts, Florentine Belts.) Iron, etched, gilded, with leather lining, probably Italian. Latin inscription translates as: "Everyone, even those attempting with a finger, will be judged. Sex offenders beware."

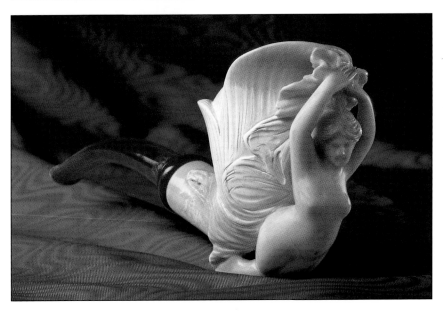

Phallus made from glass
Designed by Renato Analué, Italy, ca. 1960. This glass sculpture was originally in the private possession of the writer Alberto Moravia.

Pipe with Nymph
Meerschaum pipe with practical amber mouthpiece, Vienna, second half 19th century.

36

The idea of the embrace was a central preoccupation of German romantic poetry. At the same time the theme of the pain of abstraction also emerged. According to Kleist, communication can only be successful if one does not exchange words but only gestures; the establishment of physical contact is a fundamental condition for this communication. In the short text Letter from One Poet to Another, he writes: "If by writing I could seize the

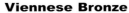

Viennese Bronze

During the reign of the Emperor
Franz Joseph, Vienna became a
center of the artistic metal
processing industry. The works
later known as Viennese bronzes
were a specialty of the Viennese
art and craft industry in the years
between 1870 and 1930.

thoughts in my heart, if I
could hold them in my hands
alone, unassisted, and if I
could put them into your
heart: then, to tell you the
truth, I would have achieved
everything I could have
wished for."

Kleist develops a theory
according to which true poetry
makes words superficial by
becoming a language of
gesture rather than a language
of words.

**Woman under a
movable clothes**
Bronze.

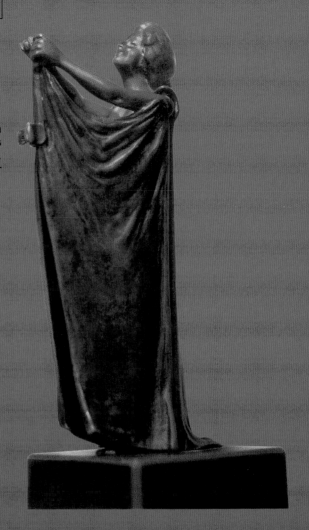

Thus the hand is truly both a passive and active organ of communication. People who use it in this way understand each other less through the use of reason than through 'feeling', not only in an emotional sense but also in a process which is genuinely tactile.

"The feelings in this heart, o young man,
Are like hands, and they caress you." (Penthesileus)

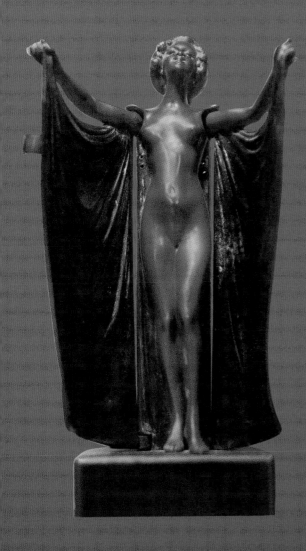

These words remind us that language in its beginnings was a language of gestures and body.

The close connection between tactile sensations and a person's inner feelings is expressed very clearly in the French language. Chamfort claimed "that love is nothing more than the manifestation of touch." And another Frenchman wrote, going beyond both materialism and idealism:

"Love is the harmony between two minds and the contact between two bodies."

Experiments with animals (for example, the famous one with Harlow's monkey) have demonstrated that limiting bodily contact can cause serious developmental problems in individuals. These problems do

Woman pulling up stockings
Vienna bronze. Ca. 1920.

p.42-43 : A monk – and what he is thinking of
Vienna bronze. Ca. 1900.

not only concern their behavioural development, but also their physical growth, their capacity to defend themselves and their general state of health. Moreover, neglecting tactile sensations in the early years of life can lead to significant retardation of both emotional and intellectual development.

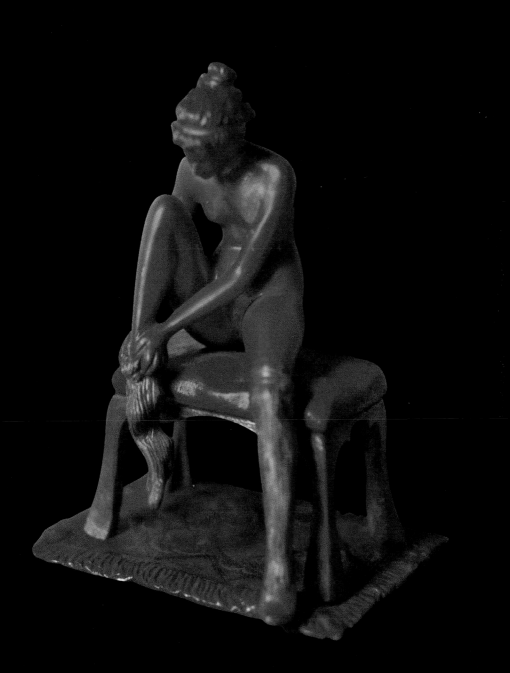

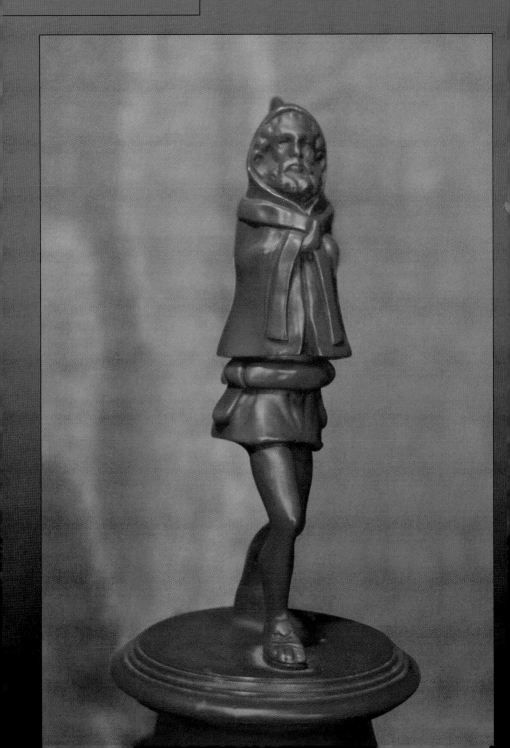

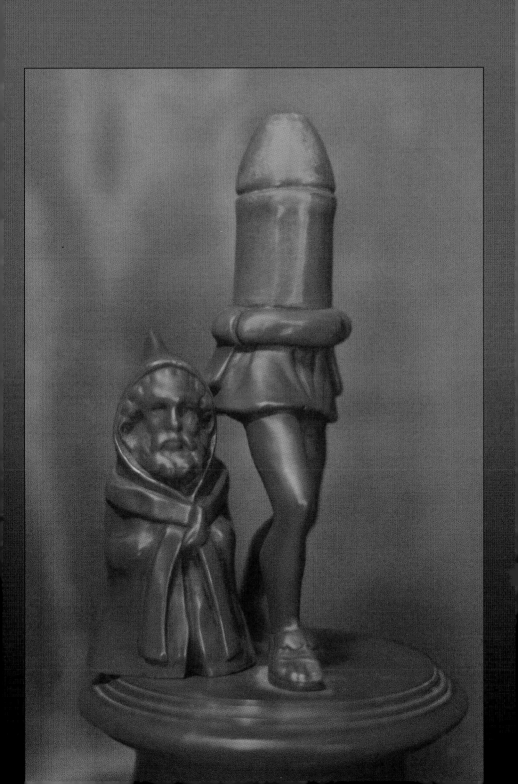

Bordello scene
In the background – the Madam collecting the money. Medallion from 18th century. The hard to recognize wine glass in the woman's hand indicates that she is a prostitute. Rear: Tortoiseshell with intarsia.

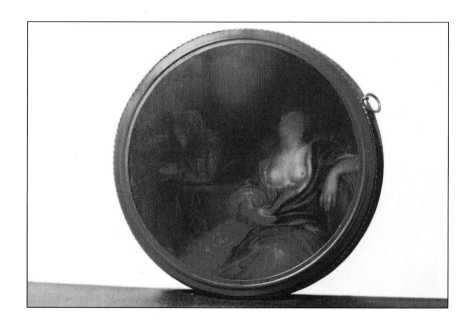

"It is probable," wrote Montagu, "that tactile stimulation represents for man a decisive factor in the developent of his emotional and affective capabilites; that the act of 'licking' is in a textual sense connected even with the possibility of love; that one cannot teach love to someone by explaining it to them, but only by loving them."

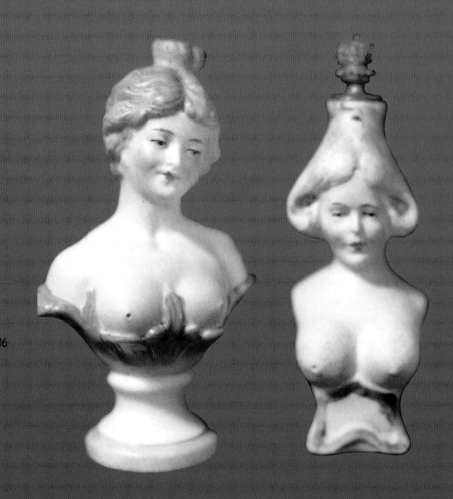

46

Tactile communication represents the first and most primitive language of the child, on which verbal language is later built. This is why people refer to the sense of touch as 'the mother of all senses.' Thus our verbal language is just a continuation of our physical language. They both have the same purpose: to establish a relationship with other human beings. Love and hate are feelings. The real significance of the word 'feeling' is connected with the first tactile experiences. (Thus the German word "Gefühl" (feeling) also

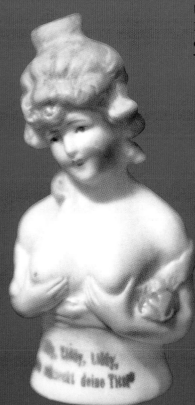

Three Female Pissers

Bisque porcelain. Belien
Ca. 1900.

designates the sense of touching something). If we like something, we want to touch it – or to 'feel' it in a sexual sense. Because in the sexual act, Montagu explains, human beings experience a sensation through their skin that is so strong it can almost equal the sensation of birth itself. Often, he says, women "use the sexual act in order to be held in someone's arms. What they desire above all else is to be close to someone; the sexual act is only the price that they agree to pay. The satisfaction of the orgy is forbidden."

Contrary to the indirect experiences of the eyes and ears, the sense of touch allows us to experience things directly in our bodies. Touch is different from the other senses "because it requires the direct and unshared presence of the body we are touching, as well as the participation of our own body

Bowl offering a risqué view from underneath
Bisque porcelain. French. Ca. 1920.

with the one we are touching." Finally, we believe in the reality of an object only when we can touch it. Even religious belief demands some kind of substance and cannot be satisfied without objects to touch: thus the relics and other objects of veneration of saints are made up of parts of bodies, bones or ashes, clothes or an object of daily use.

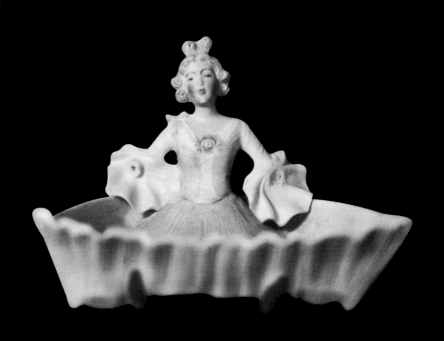

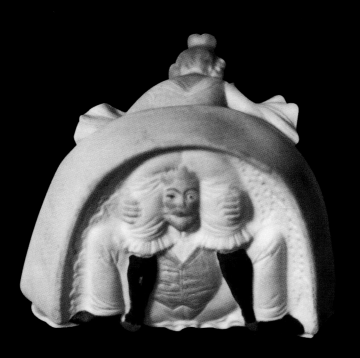

Ivory pendant
Gold and one pearl.
(Man's) hand grasping a
penis. Contemporary.

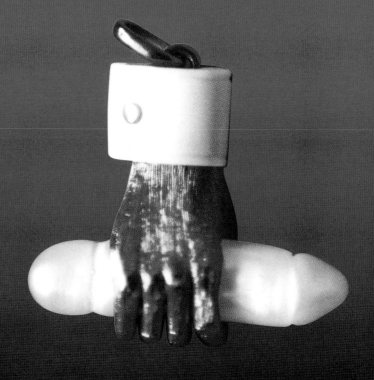

**Ivory phallus with
engravings and
silver lock**
England. 1850.

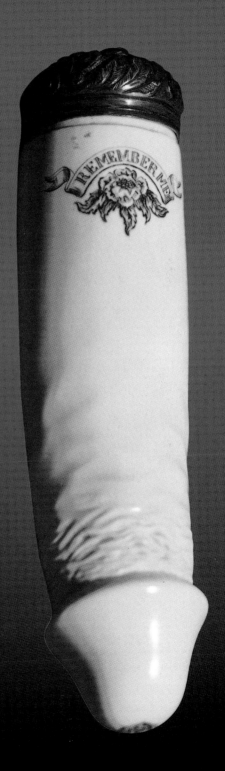

Lesbian couple
Bronze. By Lambeaux.
Ca. 1910.

52

This veneration of relics is explained by the idea that the remains of saints have preserved a specific power, so much so that the fact of touching or embracing them can effect a transfer of this specific and amazing power to the person who touches them.

Tactile contact establishes a relationship between man and saint. For a believer, a relic is like a fetish. This similarity between a saint and a fetishist is not totally far-fetched, because just like the believer, a fetishist finds the satisfaction of his desires in a piece of clothing.

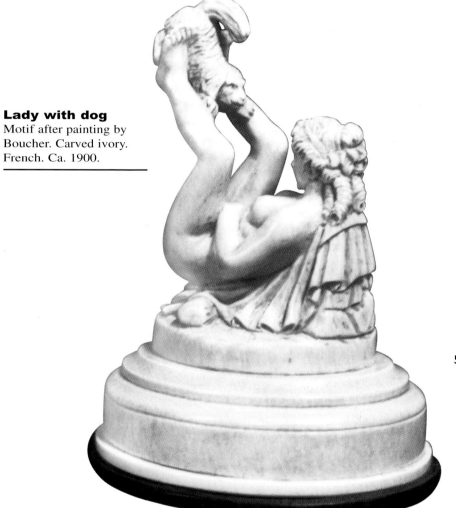

Lady with dog
Motif after painting by
Boucher. Carved ivory.
French. Ca. 1900.

53

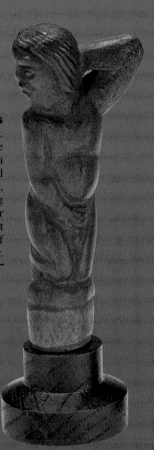
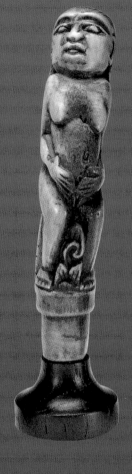

Kris Blade Handles
From Java, 19th century. The erotic kris or creese blade handles are part of a wavy, double-edged dagger made from wood, horn, and bones depicting demons, ancestors, or gods, which are to protect the carrier or owner of such a dagger.

54

For the fetishist, the sense of touch is completely separated from the image of woman as a sexual object, as a piece of clothing can sublimate all desire in his eyes. Krafft-Ebing gives us an impressive number of examples:

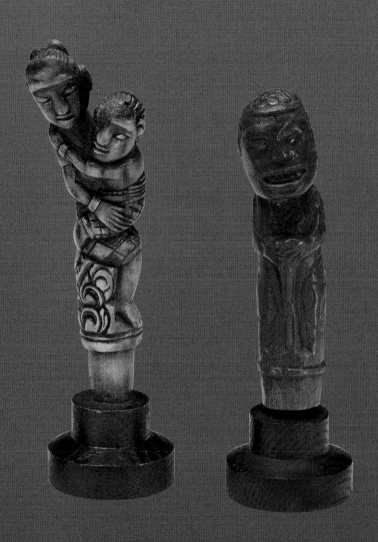

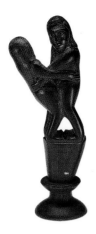

"Observation 110: Z, 36 years old, university student, has until now only been interested in the 'outer wrapping' of woman, never in the woman herself, and he has never had sexual relations with one. Under the general 'chic' and elegance of female dress, his preferred fetishes are underclothes, embroidered

56

Kris Blade Handles

From Java, 19th century.
The erotic kris or creese blade handles are part of a wavy, double-edged dagger made from wood, horn, and bones depicting demons, ancestors, or gods, which are to protect the carrier or owner of such a dagger.

Ritual Phalli

Bali, 20th century.

cambric blouses, corsets, delicate and silk-embroidered petticoats, as well as silk stockings. His pleasure consists of looking at and touching these garments on the shelves of department stores."

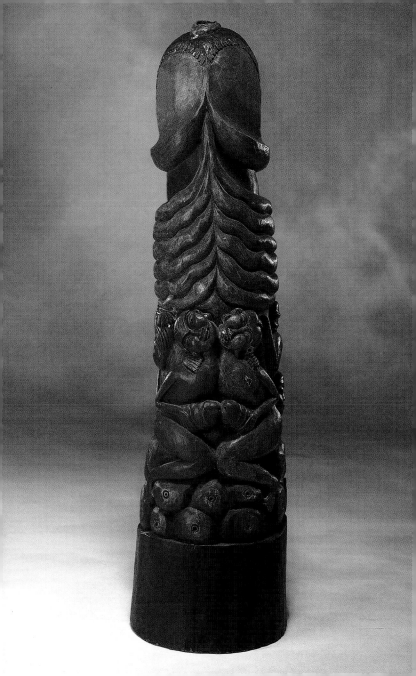

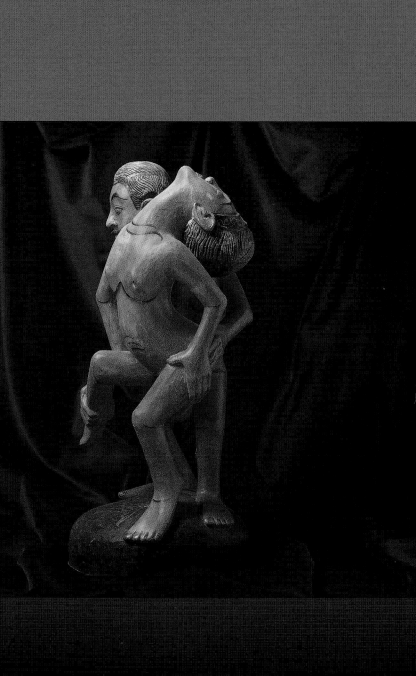

Love Positions
Bali, contemporary work.

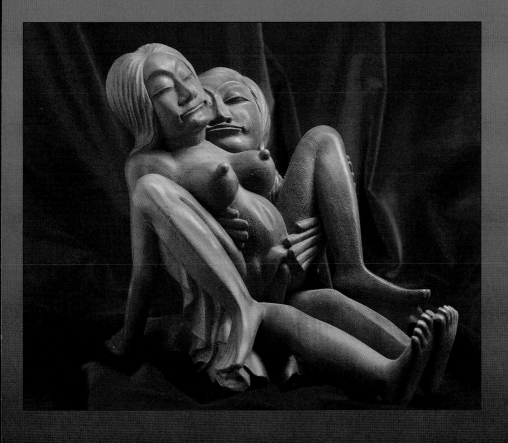

Love Positions
Bali, contemporary work.

60

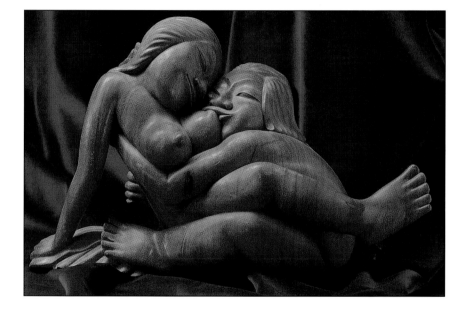

Other examples mention fetishists of petticoats, handkerchiefs and shoes. However, an object can become a fetish without being in any direct way related to a woman's body, manifested for example in the desire for a certain type of material, which can create erotic sensations in itself. Fur, velvet and silk are well-known examples in this

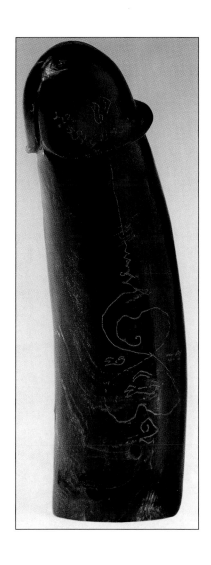

Ritual phallus from Bali
20th Century

category. Krafft-Ebing cites the case of one man, "who was known in a brothel under the name 'Velvet' because he would dress up one of the girls in a black velvet dress and would excite and satisfy his sexual desires just by caressing his face with the edge of the dress, but he never had any contact with the girl herself."

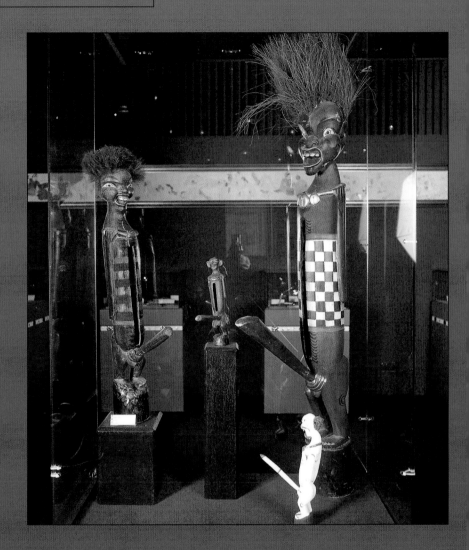

Another fetishist confesses: "From as early on as I can remember, I was always absolutely crazy about all kinds of fur and velvet, and the mere sight of these materials would create a state of sexual arousal in me, contact with them gave me a feeling of pleasure... I have a strong desire to feel these materials on a woman's body, to caress them and embrace them, then to cover my whole

Balinese Drums
The penises can be removed and used as drumsticks, Bali, contemporary work.

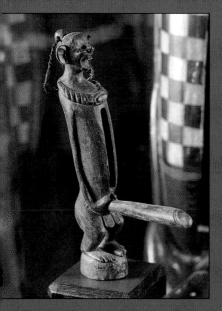

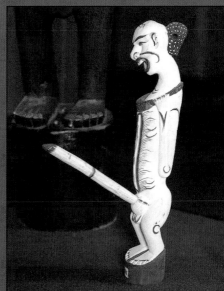

face with them. In the same way, fur or velvet alone have the same effect on me... Even more, just the word 'fur' possesses in my eyes magical qualities and stimulates my erotic imagination."

In other words, states of sexual development which in normal people are intermediate and temporary – that is, touch and sight – in fetishists come to hold a particular significance; they have, in some sense, 'gone up a grade.' Touchable material has replaced a real human being. Nevertheless, there is one conventional erotic object which

Ritual Phalli
Bali, 20th century.

64

lies at the base of fetishism: the soft skin of a mother, with all its attendant pleasures and delights.

However, not all fetishists are lucky enough to experience the pleasure of Pygmalion, whose fetish was transformed into a living goddess:

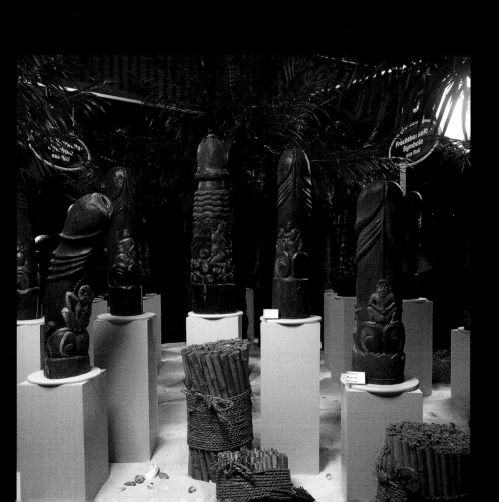

Doctor Figurines (known as Doctor Lady)

In Chine in the Empire, it was not the custom for women to undress in front of doctors. With the help of the figurines, the doctor explained to the patient the root of her suffering. 19th-20th century.

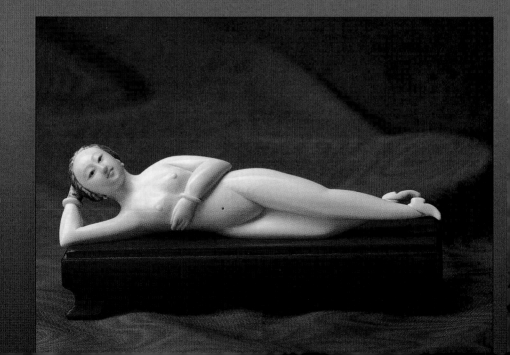

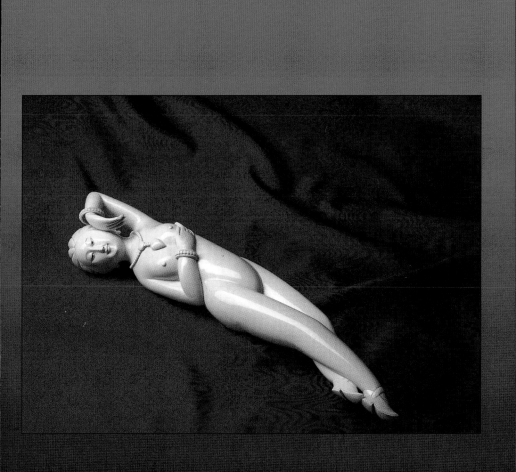

**Four Chinese
snuff-bottles**
cut coloured glass.
About 1880.

68

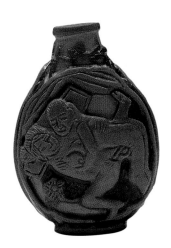

Pygmalion was King of Cyprus, and didn't want to marry because his heart and senses were completely absorbed by a snow-white ivory statue which he had created himself with such love and passion that the marble seemed alive to him.

His hand, as it caressed the statue, could not differentiate what it was feeling: was it flesh or was it ivory? Pygmalion embraced and hugged the statue, firmly believing that his love was reciprocated. By night, he lay down next to her, by day

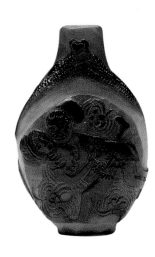

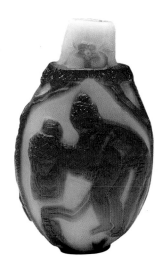

he dressed her up in costly clothes and precious jewels. Then there came the day of a festival which is very important in Cyprus, that of the goddess Aphrodite. Pygmalion went up to the altar, made his devotions and showed his respect, and prayed to the gods to give him a woman who resembled the one he had created with his own hands. Aphrodite, who was present at the festival, heard his prayer and gave life to the statue.

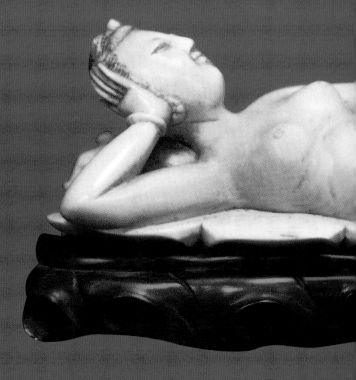

The artist Oskar Kokoschka is a sort of inverse Pygmalion. After he separated from his lover Alma, he ordered the Munich dollmaker, Hermine Moos, to make a life-sized copy of her. In his letters to her, he explained in detail how his fetish should be made. Thus, the skin should be made from soft cotton because its tactile quality was particularly important to him. "Finally, the surface of the skin should be

Chinese doctor doll
Ivory. Early 20th century.
(The larger the breasts of
these figures, the more
recent they are. Old
doctor dolls show very
flat breasts.)

71

as soft as a peach, without
visible seams which would
remind (him) that this fetish is
nothing more than a vulgar
doll made up of rags." He
added:

"Please differentiate between the tactile sensations of soft and hard, especially in the places where muscular tissue and soft tissue move under a covering which is rather similar to leather." The "shameful parts" should be made with the same attention to detail, with hair, "because otherwise it will not be

Piece from a Chinese porcelain set with 9 pieces
19th century.

Mushroom and seashell as genitalia symbols
Japan. Bisque porcelain. Meiji period (1868 – 1912).

a woman but a monster." Because for him, "this is something that he should be able to embrace." By looking at and embracing his fetish, his lost lover would reappear, living, before him.

天地の恵を
受けて
実るらん

**Japonese vase
with erotic
decoration**
Ca. 1920

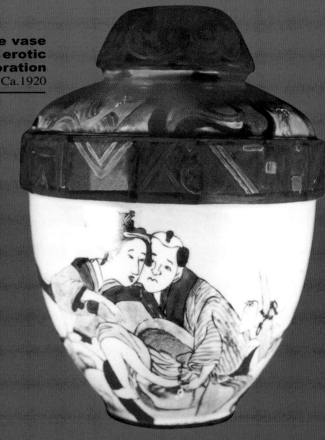

74

What he received in the end
was a monstrosity. Kokoschka
did not want to believe that he
had asked for the impossible:
the magic of a living being.
Soon afterwards, the doll
suffered a decadent and
ignominious end: at the end of

a heavy night's drinking, she
was doused in wine, decapitated
and thrown in the garbage.

Just as in psycho-sexual
development the genitals
finally become the executive
organ of desire, so the hand

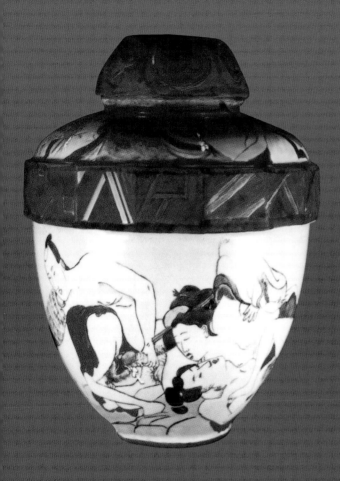

becomes the executive organ
of touch. It is the active party
in the appropriation of the
world, the medium of
knowledge between subject
and object. And what is
cherished by the infant is not
derided by the philosopher:

for Hegel, knowledge cannot
be acquired by splitting
subject and object, in which
the object is understood as
something different from the
thinker who is contemplating
it.

In order to understand the world, man must first appropriate it. For him, as for Spinoza, Goethe and Marx, man is only alive if he is productive, if he captures the world outside himself by expressing his own human predispositions to form a sort of bridge between inner and outer worlds.

Japonese vase with erotic decoration.
Ca.1920

"Man," says Goethe, "can only know himself by knowing the world that can only be perceived inside himself, as he cannot reflect himself except within himself. Every object, properly contemplated, opens a new organ to us."

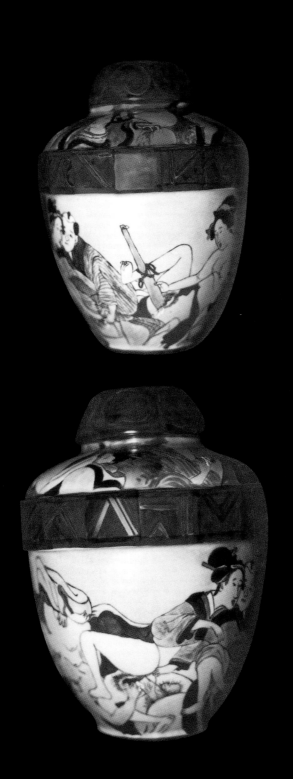

Peach bowl
From below: female genitalia. Japan. 19th century. The peach symbolizes the female genitalia.

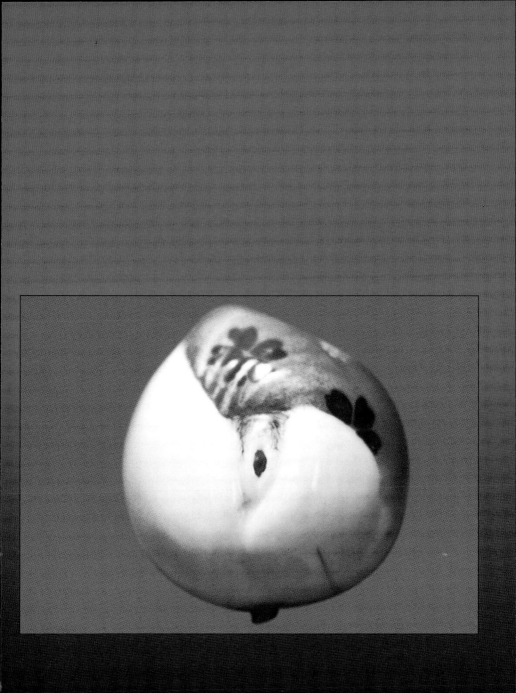

80

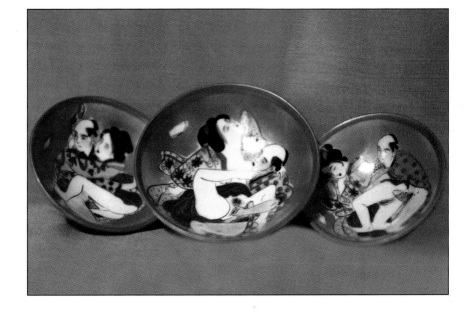

In today's world, in which our experiences are first and foremost transmitted virtually, by various media, there is a palpable decrease in our sense of reality. From the point of view of the sense of touch, our urban life is sadly monotonous: the smooth surfaces of synthetic materials offer little in the way of tactile experiences. The anonymous mediation of the outside world, whether it is via television or internet chatrooms, makes personal

Porcelain bowl
Painted on bottom. Japan.
19th century.

**Three porcelain
bowls**
Japan. 20th century.

**Sake bowls with
erotic paintings**
Japan. Contemporary.

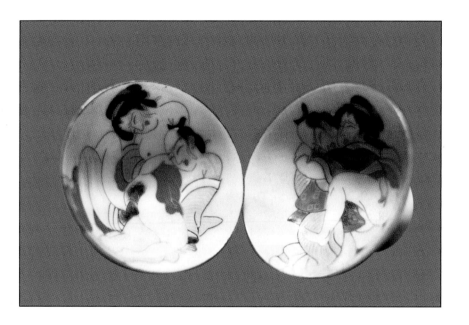

81

contact less frequent and less substantial. In the shadow of the hysterical debates around sexual abuse of minors, the tiniest sign of affection becomes suspect. The 'confession' of a mother who said she had felt pleasure in breastfeeding her child, so an article from the US tells us, led to formal charges being made against her.

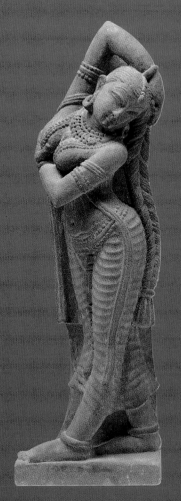

Sarasundari
Heavenly pleasure
maidens, modern.
Sandstone sculpture.
Indian typical motif. In
the imagination of many
Hindus is a paradise
peopled with ever-willing,
never-satisfied pleasure
maidens.

82

Children spend most of their time in front of the television, and those who live in large cities suffer particularly from this lack of reality. Not being able to experience the world concretely through the sense of touch, they must of necessity appreciate it as unreal. Sexuality is subjected to the same process of alienation. In these days when AIDS is such a danger, a German medical professor in all seriousness recommended using erotic telephone lines as the only method of sexual contact that was risk-free. Physical contact is dangerous even today!

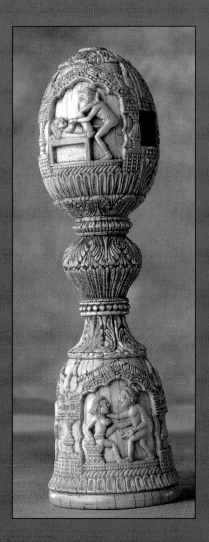

Ivory Stelae Depiction from the Kamasutra

The Kamasutra describes a variety of love positions with five of them being depicted here. Beginning of the 18th century.

In any case, experiencing those things that are near to us through the sensual act of touch remains something that is neglected in the West and is often treated as a taboo. Thus a trend which has been developing for a long time in our civilization comes to its conclusion. The 16th century could still be seen as a period of real, palpable smells, fragrances, sounds and

Temple Dancer
India, 19th-20th century. Presumably part of a procession carriage.

bodies. But the Christian denigration of the body has gradually and inexorably silenced this reality. Body and soul are, in the mind of the public, two completely separate things.

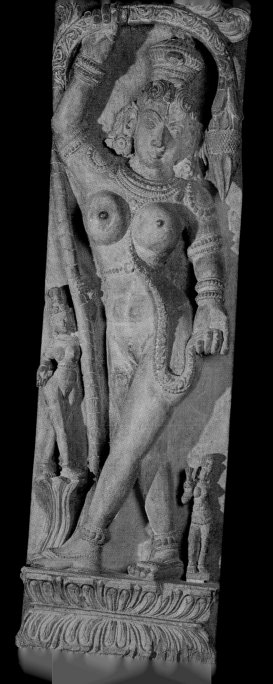

Copy of A Temple Relief
India, 19th century.

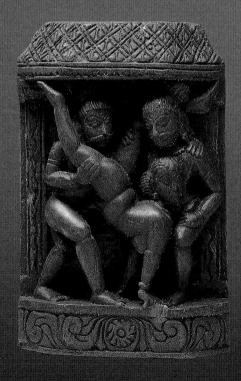

Replica of a
Temple Relief from
Khajuraho
Partly cut from soapstone.

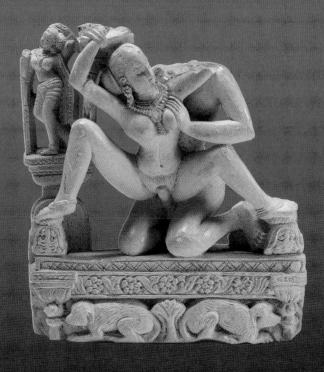

Cult vessel
Peru- Moche culture, 4th-9th
Centry AD. Clay receptacle ;
copy. Original in National
Museum of Anthropology
and Archeology, Lima.

**Lovers in Various
Positions**
Mexico, replicas from 18th
century motifs.

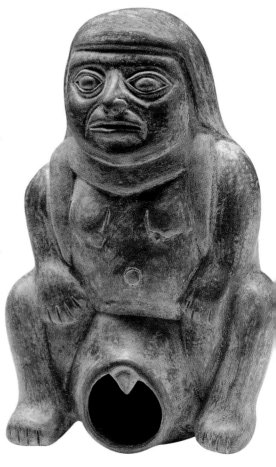

88

Herbert Marcuse wrote that
civilisation demanded the
suppression of any feeling of
closeness, thus guaranteeing
the desexualisation of our
organism by mutating it into
an 'instrument of work.' "Our

bodies as bodies are less and
less useful," wrote Rudolf zur
Lippe. "Our limbs serve more
and more to operate systems
that are more or less
autonomous. Our bodies, in
contrast, are no more than the

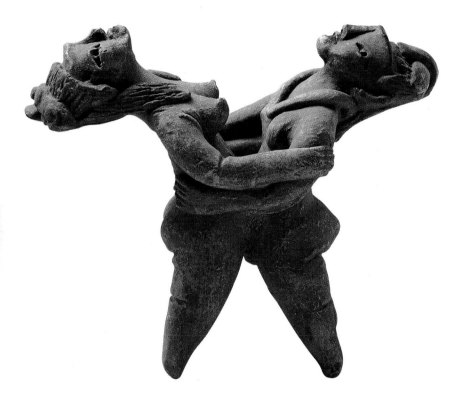

carriers of our head, which
works in isolation, or other
trained systems that function
automatically, such as arms or
hands."

Lovers in Various Positions
Mexico, replicas from
18th century motifs.

Flute Player
Mexico, contemporary
work.

90

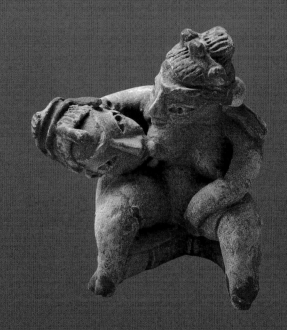

One of the great negative
successes of Christianity has
been the association of the
pleasure of touch with the idea
of sin. In contrast to Asian or
African cultures, in Europe we
have rarely proposed the

'physis' of man as a means of
development. This lack creates
a hunger to touch whose
echos are found in
contemporary pop music.
"Touch me," sing the Doors,
and 'touch' is surely the most